JAMES DAUGHERTY

(1887–1974)

ESSAY BY WILLIAM C. AGEE

 Spanierman Gallery, LLC WWW.SPANIERMAN.COM

LATE ABSTRACTIONS

JUNE 6 – JULY 6, 2002

45 EAST 58TH STREET NEW YORK, NY 10022 TEL (212) 832-0208 FAX (212) 832-8114
RALPHSESSIONS@SPANIERMAN.COM

Cover:
ALTAR TO THE UNKNOWN GOD
(detail of Cat. 30)

Published in the United States of America in 2002 by
Spanierman Gallery, LLC, 45 East 58th Street, New York, NY 10022.

Library of Congress Control Number: 2002104973

ISBN 0-945936-50-8

Design: Marcus Ratliff
Photography: Roz Akin
Composition: Amy Pyle
Color imaging: Center Page
Lithography: Meridian Printing

ACKNOWLEDGMENTS

IT IS ALWAYS a great pleasure to present the work of an important American artist, even more so when that work is previously unknown outside of a small circle of family and friends. James Daugherty's role as an early twentieth-century modernist has been acknowledged, if not fully appreciated, for many years. His return to abstract color painting during the last twenty years of his life, on the other hand, is a remarkable story that has not been told until now. We are pleased to bring much-deserved recognition to this overlooked phase of his long and distinguished career.

As William C. Agee so ably demonstrates in his essay for this catalogue, Daugherty's return to abstraction in the early 1950s was not retrospective, but a bold foray into colorism that bridged two generations of modern art. He continued to find inspiration in the contemporary world, moving his art in new directions while at the same time referencing his modernist beginnings. The works in this exhibition evidence a strength and assurance gained from a lifetime of painting.

I am fortunate to have had the opportunity to guide this exhibition and catalogue to their completion. I did not originate the project, though, and have many people to thank. First, Charles and Lisa Daugherty, the son and daughter-in-law of the artist, have generously shared the papers and records that they preserved over the years along with the paintings included in this exhibition. John Solum worked diligently in gathering information on James Daugherty's life and art, and compiled the chronology and list of institutional collections presented here. Professor Agee's enlightening essay provides a succinct overview of the artist's many contributions to twentieth-century American art, while also presenting new information that establishes the significance of his late work.

As for Spanierman Gallery, I extend many thanks to Deborah Gerstler Spanierman and Betty Krulik, both of whom directed the project before I assumed the responsibility for it. Deborah has been especially gracious in answering all of my questions. Lisa N. Peters oversaw the editorial process, and Fronia Simpson did a fine job of editing. Marcus Ratliff and Amy Pyle have, as always, created a striking design for the catalogue. Special thanks are also due to Rosalind Akin for photography and Christina Vassallo for editorial assistance. And, of course, Ira Spanierman must be recognized for appreciating the importance of Daugherty's late work from the onset of this project, and for his support throughout its development.

Ralph Sessions

JAMES DAUGHERTY (1887–1974):

LATE WORK OF A PIONEERING AMERICAN MODERNIST

WILLIAM C. AGEE

W RITING IN 1949, James Daugherty declared with his usual optimism that modern art was nothing less than "liberating and expansive, rousing and freeing human consciousness from materialism to infinite possibilities of living, creating universal harmony, energy and renewal."[1] One could easily have assumed that Daugherty, who was then sixty-two, was simply looking back to the early years of the twentieth century and his own beginnings as a pioneering modernist artist. As it turns out, however, this was only part of it, and his statement now has a new, and prophetic meaning. Daugherty was looking ahead, as if issuing a personal manifesto for a renewed burst of abstract painting to take place. The results of these almost twenty years of painting, begun in 1953 and ending only with his death in 1974 at the age of eighty-seven, are now before us, exhibited here in depth for the first time.

The late paintings are startling, revealing, even astonishing in their clarity and brilliant color. Their power and resolution strike us as the work of a man half his age. They bring us to a new and fuller understanding of the life and art of Daugherty and, indeed, of a significant portion of modernism in America. They fill out and make whole his long career, revealing just how long and deep his art ran in the course of the twentieth century. This burst of glorious painting calls to mind the later art of Henri Matisse and Hans Hofmann, who, like Daugherty, were also in their eighties when they completed their last works. Like theirs, Daugherty's last paintings were not just the culmination of a long career but a veritable rebirth, an entirely new and youthful phase of a rich and varied life in art.

The late paintings form a true *alter stil*, a distinctive old-age style, that extended further into the century than that of any other first-generation American modernist. Their roots can be traced to Daugherty's early ventures in modernism, before World War I, but they are anything but rehashes of earlier work. They are new and distinct, breaking new ground for himself personally and for the history of American art. They extend the color principles that he had learned in New York in 1914–17 and should be understood as a later contribution to a long tradition of color painting that had given rise to some of the best and most important art of the twentieth century, from Matisse to the present day.

Prior to his immersion in the language of color painting in 1914–17, Daugherty had been gradually working his way into modernist art. He was born in 1887, in Asheville, North Carolina, and grew up on farms in Ohio and Indiana before the family moved to Washington, D.C., where his father was employed.[2] It was a cultured family, and from a young age he drew and made illustrations in response to the great works of literature that his father read aloud to the family. He was clearly talented, and by 1903 he was taking evening classes at the Corcoran School of Art, and in the following years he studied first with Hugh Breckenridge and then with William Merritt Chase and Henry McCarter at the Pennsylvania Academy of the Fine Arts in Philadelphia. From 1905 to 1907 he lived with his family in London, where he studied with Frank Brangwyn. Daugherty later described his time with Brangwyn as "paralyzing,"[3] but Brangwyn's long experience with mural painting surely helped to prepare Daugherty for his own career as a muralist during the 1920s and 1930s. By 1908 he had returned to the United States, settling in New York, where he did illustrations to support himself while continuing his studies at the National Academy of Design.

In 1913 his eyes were opened to a world of new possibilities by the landmark Armory Show and his discovery of a book by C. Lewis Hind, *The Post-Impressionists*, which had been published in 1911. As he later described it, he "went modern with a vengeance." His absorption in modernism was also furthered by his friendship with Athos Casarini (1883–1917), an Italian Futurist who was then living and working in America and was a neighbor of Daugherty's. In 1914, in a series of illustrations in the *New York Herald*, Daugherty developed a Futurist vocabulary

of swirling and intersecting figures abstracted and fragmented in the nonstop movement of popular activities such as baseball and dancing. His depiction of quotidian subjects, as well as their reproduction in the daily newspapers, tells us something crucial about the man and his art. He believed deeply in America and the American people and their life, their pace, and their tempo. For him modernism was not a remote or obscure enterprise; it was always a populist and democratic art, intended to embody the essence of modern life, its speed, movement, flux, and its essential vitality and optimism, a particularly American version of Henri Bergson's concept of *élan vital* (that spiritual force or energy that underlies reality and influences matter).

Daugherty became an active participant in the art life of New York, exhibiting at the MacDowell Club and the Whitney Studio Club, when his art and life took a dramatic and defining turn. Daugherty had taken a studio at 8 East Fourteenth Street, when in 1915 another young American artist, Arthur B. Frost, Jr. (1887–1917), moved in next door. Frost, the son of the famous American illustrator of the same name, had recently returned from a long stay in Paris, where he had become close friends with the American painter Patrick Henry Bruce (1881–1936). Bruce and Frost had studied with Matisse, absorbing the French painter's lessons in color before gravitating to the circle of the *école orphique* revolving around Robert and Sonia Delaunay, whose art was based on intersecting planes of pure, abstract color. In the years prior to World War I, Bruce and Frost became well-known, founding members of an international group of artists including the Synchromists, the Americans Morgan Russell and Stanton Macdonald Wright, who explored high-keyed color as the means to abstract art.[4] In New York, Frost immediately set out to teach Daugherty the principles and techniques of color theory and color painting.

Daugherty himself was surely no stranger to color. He would have been made aware of it in Hind's book and he would have seen the many paintings of intense color, including works by Vincent van Gogh and Matisse, at the Armory Show. Indeed, his Futurist works, the 1914 *Cabaret* (*Café Chantant*) (Fig. 1) among them, were marked by sequences of strong, bright color, adding to their "expansive, rousing" mood. However, Frost's passionate belief in and understanding of the possibilities of color quickly

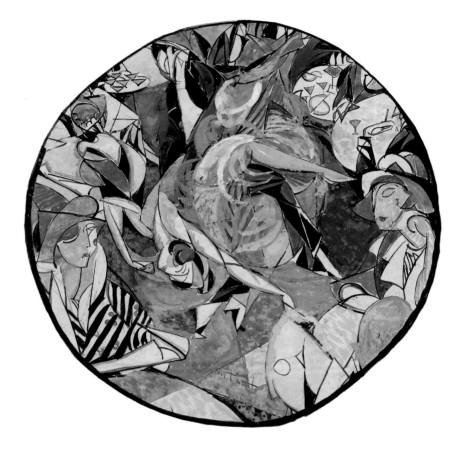

Fig. 1. James Daugherty, *Cabaret (Café Chantant)*, 1914, ink, watercolor, gouache, and graphite on paper, 12⅛ inch diameter, tondo, Amon Carter Museum, Fort Worth, Texas

convinced Daugherty. He became a receptive and diligent student and was soon applying these ideas to his own work, first in a figurative manner, then increasingly in works of greater abstraction.

Daugherty and Frost were concentrating on the prismatic hues, raised to their highest value, when sometime in late 1916 or early 1917 Frost received a shipment of six *Composition*s Bruce had produced in Paris in 1916. They seemed to continue the type of color abstractions Frost knew well from working with Bruce. However, Frost quickly realized that they contained a new and revolutionary element: Bruce had incorporated large areas of black and white along with the familiar primary and secondary colors. Daugherty later recounted that Frost was thunderstruck by this development, for the modern color painters had understood that since Impressionism black had been banished from the artist's palette. A basic modernist law had been reversed, with powerful and effective results, by increasing and heightening the range of color expression. Frost immediately set about repainting a large abstraction

he had been working on, and soon Daugherty, too, began to include such passages in his own work; it became a practice that informed Daugherty's art for the rest of his life.

We often think of American modernism as behind the times, but this is not true, for by 1916 New York had become a vital part of the hybrid internationalism of modern art. In that year on East Fourteenth Street, these two young artists were helping to define some of the most advanced ideas then current. The newest color theories, published in 1916 by Wilhelm Ostwald,[5] had established black and white as primary colors, according them equal status with the familiar hues of red, blue, and yellow. The use of black and white was quickly adopted by Matisse and was soon evident in the work of Piet Mondrian, among others. It was Bruce, Frost, and Daugherty who brought the practice, which had broad implications for painting, into the vocabulary of American art, simultaneously with its spread in Europe.

There was another development in the *Composition*s that was equally important and that heralded significant changes within modern painting. Bruce's paintings, all done in 1916, were based on the observation of people in motion at the fashionable Parisian dance hall, the Bal Bullier, which he and Frost had frequently attended. The first *Composition*s were recognizably figurative, with multiple overlapping shapes, fusing in simultaneous sequences. The later paintings, however, became progressively abstracted and clarified, with stronger and more clearly delineated outlines. In the last of the series, the forms became more stable and precise, actually suggesting three dimensions, with a distinctly structural and architectural format, suggesting large-scale still lifes.[6]

This move to more linear, condensed formats was the response of artists and writers to the carnage inflicted by World War I. As the war dragged on, with no end in sight, it was clear the world had changed profoundly. The old prewar optimism, the belief in multiple possibilities was gone, and artists and writers began to chart a new course for art and for society. In 1916, in the small Parisian magazine *SIC* (*Sons, idées, couleurs* [Sounds, Ideas, Colors]), voices of a new tenor appeared, writing, as Guillaume Apollinaire did, that "the war will change things…we will move to a simpler expression, to attain a greater perfection"; others spoke of how the artist will "consolidate and distill" from the old multiple

emotions, of how the artist will now "construct a work as an architect makes a house." These expressions coincided exactly with the formal shifts within Bruce's *Composition*s and announced a shift in world art, including American, from the old Futurist, simultaneist abstraction to a more reductive, more clearly constructed art. It led to a new vision of the world, one of peace, order, and harmony, as evidenced by the "call to order" in France, De Stijl in Holland, Constructivism in Russia, the Bauhaus in Germany, and Precisionism in America.[7] We think of these changes as occurring after the war, but in fact they were formulated in 1916, simultaneously in America and Europe. In America they were announced by Bruce's *Composition*s as well as by Marsden Hartley's reductivist paintings of 1916, Morton Livingston Schamberg's machine paintings, and the razor-edged Cubist works of Charles Demuth. If less well known, the paintings of Frost and Daugherty also were among the first to announce this change. By 1918 Daugherty was painting both organic abstractions and, increasingly, more geometric, precise abstractions such as that of 1918, now in the collection of the Museum of Modern Art, New York. In their own way they point to the "universal harmony" he declared in 1949 as one of the fruits of modern art. To the end of his life, in his late work, this duality of the organic and the geometric defined the two most prominent aspects of Daugherty's art.

Frost and Daugherty achieved their most productive collaboration in late 1917. However, Frost, frail from long bouts with tuberculosis, succumbed to the fast pace of life he was leading in New York and died on December 7, 1917, four days before his thirtieth birthday. Daugherty took up the cause of teaching color abstraction and passed on the principles of color painting to his circle of friends, including such artists as Jay Van Everen (1875–1947) and Alexander Couard (1891–1926), who in turn created a body of early abstract color painting. Daugherty had become the leader and teacher of a small but influential group of painters, an intrinsic part of avant-garde painting in America, important even if overshadowed by the more famous circle around Alfred Stieglitz.

The Great War brought other changes for Daugherty as well. The Navy employed him to paint camouflage on warships, an experience he used when making a series of large-scale paintings depicting tumultuous battle scenes. The sheer size of these paintings prepared him to undertake

in 1920 a commission for a set of four vast murals in the lobby of the Loew's State Theater in Cleveland. These murals, currently under restoration, are one of the glories of American art of the 1920s and will force us to revise our thinking of that period. Although figurative, they are not a retreat or a loss of confidence, as so much of American art of the time has been commonly viewed. Part of the shift in the worldview of artists after the war was the desire to integrate art and life more closely, to relate modern art in a more comprehensible way to every-day life and to a larger audience. The most direct way to achieve this was the use of figurative imagery, and there was no better medium for this imagery than the large public mural, so much in evidence during the 1920s and 1930s in America. The vast Cleveland murals, each forty six feet wide, retreat from nothing. They blaze forth into new and unknown domains in the life of color, dazzling and unfurling across the walls; their likes were not seen again until the large murals done for the Paris International Exposition of 1937 by Robert and Sonia Delaunay. The works in Cleveland, as well as a large-scale two-sided canvas, completed in 1922 (Figs. 2–3), mark Daugherty as a key artist of the 1920s. He continued as a major mural painter on the government art projects

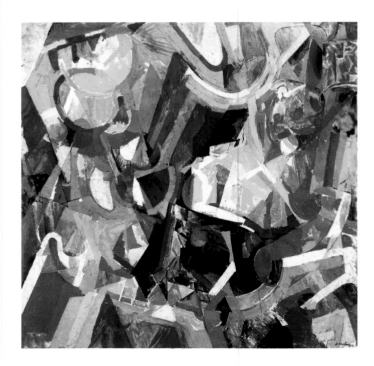

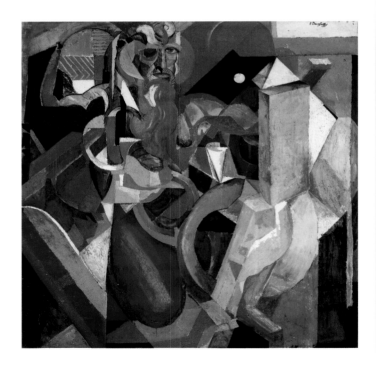

during the 1930s. Without knowing his history, it was easy enough to think that his wall paintings of the 1930s followed in the wake of those of Thomas Hart Benton, but we now know Daugherty was an accomplished muralist long before Benton was.

By 1923, with a family to support, Daugherty had moved to a house in rural Connecticut and had begun again to write and illustrate children's books, many of them becoming award-winning classics in the field. With the coming of World War II and the end of the WPA mural projects, his career as a muralist and a painter, as fine as it had been, seemed to later observers to have effectively ended. The emergence of a younger generation of artists, the Abstract Expressionists, brought worldwide acclaim to American art and almost entirely shifted attention away from the early modernists. Indeed, the perceived gulf between the two generations became so wide that a virtual iron curtain between pre- and post-1945 American art appeared, as if dividing two separate countries and cultures.

In the early 1960s, when I began to research early modernism and color painting, Daugherty was hardly known except as an illustrator. His recovery as an important and original member of the American avant-garde was one of the real joys of that research campaign. The historical focus of that research, and his innate modesty, however, obscured the fact he had never stopped painting and that he had resumed making abstract color works in 1953.

Just exactly what had inspired him to return to abstract painting is not certain. We do know that he admired the Abstract Expressionists, particularly the luminous color of Mark Rothko, whom he believed had taken art to its "ultimate."[8] Daugherty saw no break or barrier between earlier and later modernism. He embraced the continuity between the two generations of modern art; he understood that Rothko and others were building on what he had been instrumental in establishing. We do not now know for certain, but the example of the powerful color in the late work of Matisse and Hofmann, other artists who spanned both generations, also may have been a stimulus for Daugherty. There are also a few late works, not exhibited here, that suggest that he had seen the work of Pierre Bonnard, whose death in 1947 had occasioned a widespread reconsideration of that artist as a modern master of color.

The first of Daugherty's later paintings were small and done in an irregular geometric format of broad horizontal and vertical bands, with a relatively stable composition and subdued palette on textured, painterly surfaces of a material, palpable reality (Cats. 1, 3). They are not the precisely edged surfaces of Mondrian and the De Stijl artists, but they suggest the pervasive influence exerted by Mondrian after his death in New York in 1944. American artists as diverse as Hofmann, Stuart Davis, and Robert Motherwell deeply admired the clarity and order in Mondrian's art, a model for world harmony, paralleling the "universal harmony, energy and renewal" that Daugherty had spoken of in 1949.

If at first he seemed to be feeling his way, gradually working back into the discipline of abstract painting, he soon enough found his old pace and assurance. He opened his formats to more complex configurations, as in *Abstraction (Interlocking Angles)* (Cat. 9). By 1957–58 he was working at full throttle, expanding to much larger size and breaking from the grid in *Abstraction* (Cat. 5). Here Daugherty retained powerful verticals, distantly suggesting Mondrian, but deployed in idiosyncratic bands structured with a heightened range of color that extended the full range of the spectrum from dark to light. In paintings such as *Tensions* (1957) (Cat. 4) and *Aldrin* (1958) (Cat. 6), the formats became increasingly complex, with multiple intersections and turnings, an entire vocabulary of angled shapes that seem in themselves to manifest the "liberating and expansive" art he had written of in 1949.

Daugherty continued to alternate modes, as was his long-standing habit. In 1961 he returned to the old rectilinear format of vertical and horizontal, but these elements were now joined by an additional element, a circle or circles, and a distinctly new feel. *Abstraction with Red Sun* (Cat. 11), probably the first of the series, retained a heavily textured surface, but two subsequent works, *The Day the Sun Stood Still* and *Yellow Sun* (Cats. 10, 13) show a lighter, more refined painterly touch. Their layered, almost transparent color planes surely recall the color veils of Rothko's art that he admired and that now gave a new dimension to his art, a serene and meditative quietude. The color of *Yellow Sun* corresponds exactly to its title, for it is in a high-keyed brilliant chord of yellow; the second painting is in a deeper, rich, more resonant note. As the titles tell us, the subject is the generating source of life itself, the sun. Thus, the

paintings refer to the cosmos, the vast universe in which we live, a subject that had long run deep in modern art. The brilliance of light and color in *Yellow Sun* and its aura will call to mind a tradition dating back to the American Luminists, the sun paintings of van Gogh, and the variations of Orphic circles of light found in the works of the Delaunays, Bruce, Frost, and in Daugherty's own early abstractions. In turn, Daugherty's painting points to and reflects the new clarity and luminous color of late 1950s and 1960s art, such as we find in the burst paintings of Adolph Gottlieb, the concentric circles of Kenneth Noland, and in much of the newer color field painting of the time. In this way, Daugherty both affected and in turn was affected by newer developments, an age-old process of art.

Daugherty's sun paintings make explicit one of the generating and sustaining forces of his art and indeed of his very life, both early and late. He was a deeply spiritual man, a man of profound faith who believed in God and in the power of prayer. His art conveys optimism in the fundamental goodness of the world, its wonder and glory. He had faith in the redemptive power of love, which tells us why there was always a special aura about him. His art was nothing less than an expression of his beliefs. We need think only of the thunderous *Moses* (Fig. 3) of 1922 or the series of works based on biblical themes dating from the 1940s to understand how open his spirituality had always been.

In his abstract art, he used color and light to make "shapes of glorious majesty" that spoke of a higher power in the universe. Color composition, which he equated with the composition of music, was the "wave length of art," creating "harmonies of spiritual art."[9] His work speaks of joy and affirmation, but such an expression was not easily attained. He went through periods of intense self-doubt and questioning both of himself and his art, exacerbated by the difficulties of his wife's illness and suffering. He faced and conquered the darkness through the light and color of his paintings, finding through his faith the sustaining power that let him complete his work. Faith and art, he believed, would make "man victorious."[10] His art is intensely personal and powerful, stemming from the deepest core of his soul, which is one reason why it is so wrong to think of color painting as "decorative," in the pejorative sense, the easy and unknowing label that has plagued color painting from Matisse to the present day.

By 1965 Daugherty's work had reached an ever greater peak of size, complexity, and color intensity in works such as *Cape Canaveral* (Cat. 19), *Simultaneous* (Cat. 21), and *Abstraction* (Cat. 29). They are crowning achievements of his art, filled as they are with an inventiveness and almost ceaseless capacity for wonder in the possibilities of color. The reference to Cape Canaveral tells us that he was inspired in good measure by the exploration of space, that he saw the astronauts as modern counterparts to earlier heroes, the founders of the country in which he believed so deeply and about whom he had written earlier in his career. The explosive energies of these paintings seem literally to put into physical form what he called the "out rushing forces of the cosmos" in an "ever expanding infinitude," even reaching what he referred to as the "farthest fringes of eternity."[11] They seem to embody a new kind of Futurism, alluding to a firsthand exploration of the cosmos that he had come to know so well in his faith.

In these paintings his shapes became more precise, concrete, and three-dimensional, just as had the last of Bruce's 1916 *Compositions*, which had been so important to him. This move was made explicit in smaller pictures such as *Gravity Zero* (Cat. 20) and *The Weight of Weightlessness* (Fig. 4), which also reference the new world of space travel. Here singular shapes, each clear and distinct from the others, float freely in an unbounded space. Once again Daugherty fused the old and the contemporary, for these forms refer both to early modernism and to the abstract illusionism developed by younger artists in the 1960s such as Frank Stella, Al Held, and Ron Davis. The intricacies of all the paintings of the mid- and late 1960s will also call to mind the bright patternings in the late work of Stuart Davis, or even the radiance of a modern stained-glass window such as was pioneered by Matisse, giving forth an even more effulgent spiritual and cosmic light. So, too, we will find more abstracted but still powerful suggestions of the sun, yet again another reference to higher laws of the universe. The new complexities of these paintings reflect the new complexities of the world as explained by modern science and technology, of which the art of painting can be understood as one potent branch.

The pictorial worlds traveled in these paintings may make other references, but they finally live on their own terms, one shape suggesting

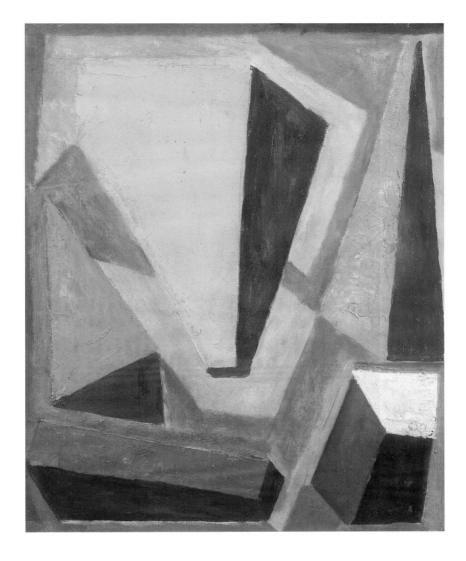

Fig. 4. James
Daughterty, *The Weight of
Weightlessness*, ca. 1965,
oil on canvasboard,
Spanierman Gallery, LLC,
New York

another, each form and color making what Daugherty called "its own
necessities and solutions as one works-acts-paints."[12] He was "working
out of the materials," a primary tenet of modernist art and particularly
modern American art, voiced in this country as early as 1903 by Alfred
Stieglitz, and it was a basic methodology of the Abstract Expressionists.[13]
Daugherty loved his materials, and his color stemmed from his old prac-
tice of working one area at a time, letting one color lead to another,
working and reworking, painting and overpainting, patiently building the
surface into a tightly knit and unified whole. This is as true in the large
paintings as it is in the small pastels on paper that he did in the 1960s
and that have their own, softer voice in their organic forms that stem

from biomorphism, the pervasive form language of the 1940s. In both the oils and the pastels, the colors interact through fundamental color principles such as the law of simultaneous contrasts, the laws of harmony and analogy, the use of gradation, and the construction of chords of color. In this way he sought to make a painting as pure and abstract as a musical composition, one that was so clearly and precisely structured that it could be viewed effectively from any one of its sides. This was his way of making abstract art concrete and real, "to establish a unity and harmony of parts" that satisfies the "elemental yearning of man for order, affirmation, beauty, truth."[14] He thought color harmony was symbolic, for "its lyricism excites and expands the mind, and intelligence, and imagination comes to life."[15]

In 1971 Daugherty noted that "the new art should explore and complete and develop the directions and discoveries of the early modernists,"[16] which he certainly did, for he always believed in the expressive power of painting. In 1949 he had made this abundantly clear when he concluded his statement by saying, "Through great paintings the artist will restore meaning to life and announce its beauty and capacity." There is still much to be learned from these paintings, but we can fairly say that his late work achieves all this, as he had hoped. Daugherty was right on all counts, perhaps most especially when he said in 1966 that "the best is now."[17]

NOTES

1. Statement in *Catalogue of the Collection of the Société Anonyme* (New Haven, Conn.: Yale University Art Gallery, 1949), 182.

2. This and many other details of Daugherty's life have been carefully and thoroughly gathered by John Solum, Weston, Conn., whose invaluable chronology is published herein. I am grateful to him for his indispensable assistance, as I am to Charles and Lisa Daugherty, the artist's son and daughter-in-law, who have preserved the records and paintings left by Daugherty with loving care.

3. This and much of the other information and quotations in this essay come from my many interviews with the artist conducted from the fall of 1963 through 1966. The results of this research and the first discussions of the artist's work appear in my *Synchromism and Color Principles in American Painting, 1910–1930*, exh. cat. (New York: M. Knoedler and Co., 1965) and my catalogue essays for exhibitions of the artist's work at the Robert Schoelkopf Gallery, New York, in 1971, and at Salander O'Reilly Galleries, New York, in 1988.

4. For more on this, see Agee, *Synchromism,* and William C. Agee and Barbara Rose, *Patrick Henry Bruce/American Modernist* (New York: The Museum of Modern Art; Houston: The Museum of Fine Arts, Houston, 1979).

5. Wilhelm Ostwald (1853–1932) was the winner of the Nobel Prize in Chemistry in 1909. With the aim of finding a scientific standardization of color, Ostwald wrote two books *Die Farbenfibel* (The color primer) and *Die Harmonie der Farben* (Harmony of the colors) and published the periodical *Die Farbe* (Color). The best recent source for how color actually works in paintings is William I. Homer, *Seurat and the Science of Painting* (Cambridge, Mass.: MIT Press, 1963).

6. For a thorough discussion and full photographic documentation, see William C. Agee, "Patrick Henry Bruce: The Recovery of a Forgotten Modern Master," in Agee and Rose, *Bruce*, 21–27.

7. See Agee, "Bruce," 24–27 for a fuller discussion and complete citations.

8. James Daugherty, unpublished diary, February 12, 1966. Collection Charles and Lisa Daugherty, Weston, Conn.

9. Diary, January 12, 1966

10. Diary, January 28, 1966.

11. Diary, February 6, 1966

12. Diary, February 18, 1966

13. For the sources and development in early modernism, see William C. Agee, "Arthur Dove: A Place to Find Things," in *Modern Art and America: Alfred Stieglitz and His New York Galleries*, Sarah Greenough ed., exh. cat. (Washington, D.C.: National Gallery of Art, 2001), 421–39.

14. Diary, February 17, 1966.

15. Diary, February 17, 1966.

16. Diary, December 18, 1971.

17. Diary, February 22, 1966.

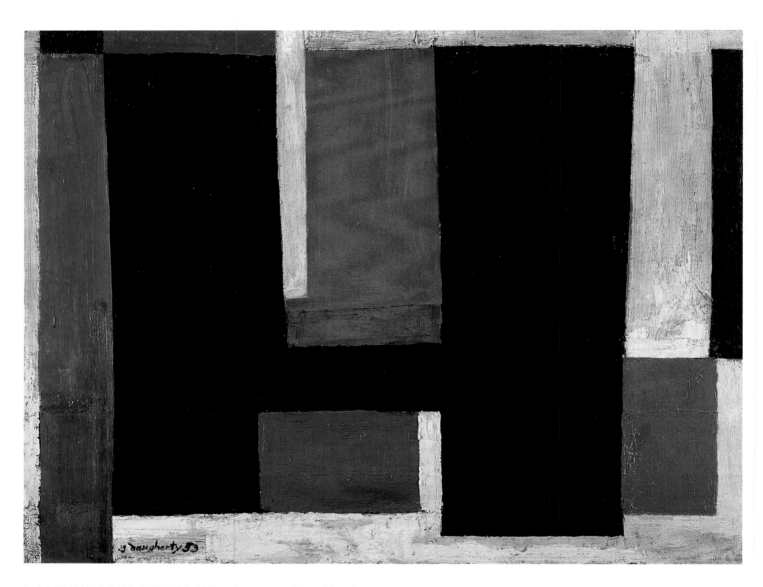

1. *PORTABLE BOMB SHELTER*, 1953, oil on canvas, 20 × 26 inches

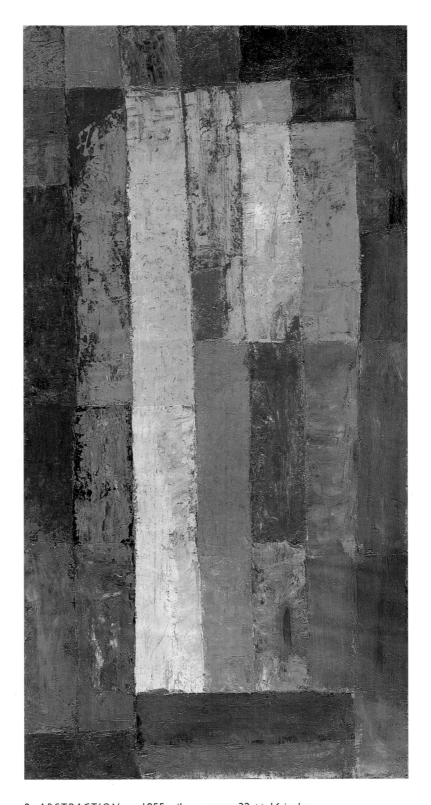

2. *ABSTRACTION*, ca. 1955, oil on canvas, 32 × 16 inches

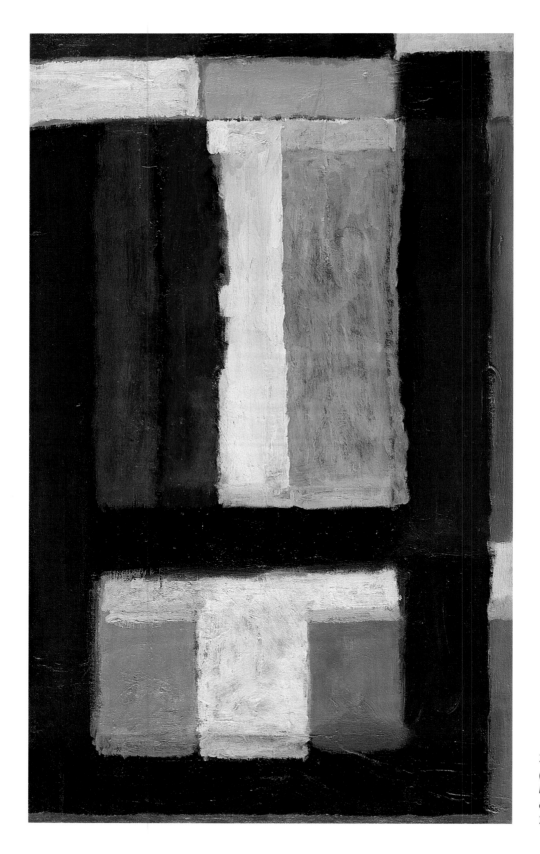

3. *ABSTRACTION (VERTICALS AND HORIZONTALS),* ca. 1955, oil on canvas, 30 × 18 inches

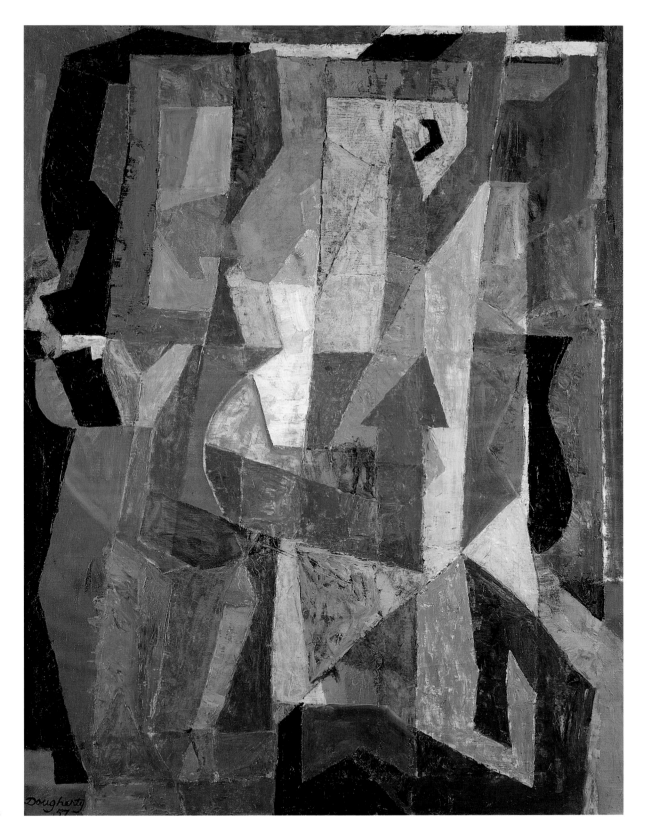

4. *TENSIONS*,
1957, oil on canvas,
58¼ × 41¾ inches

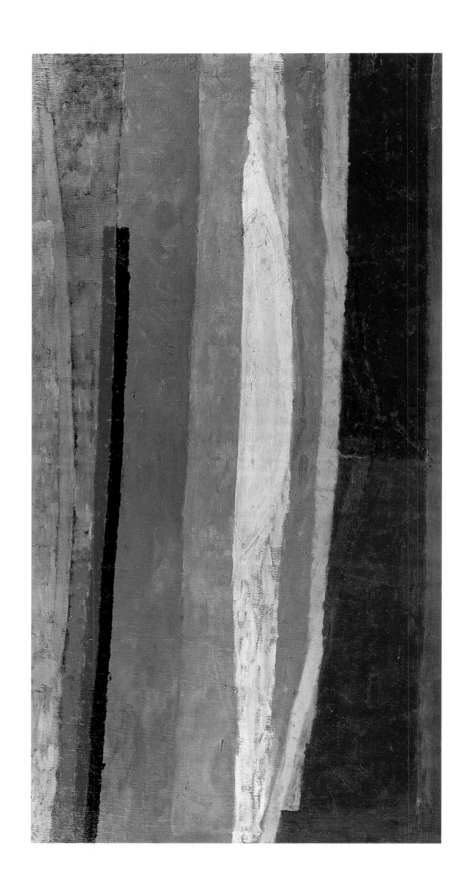

5. *ABSTRACTION*,
ca. 1958, oil on canvas,
84½ × 42½ inches

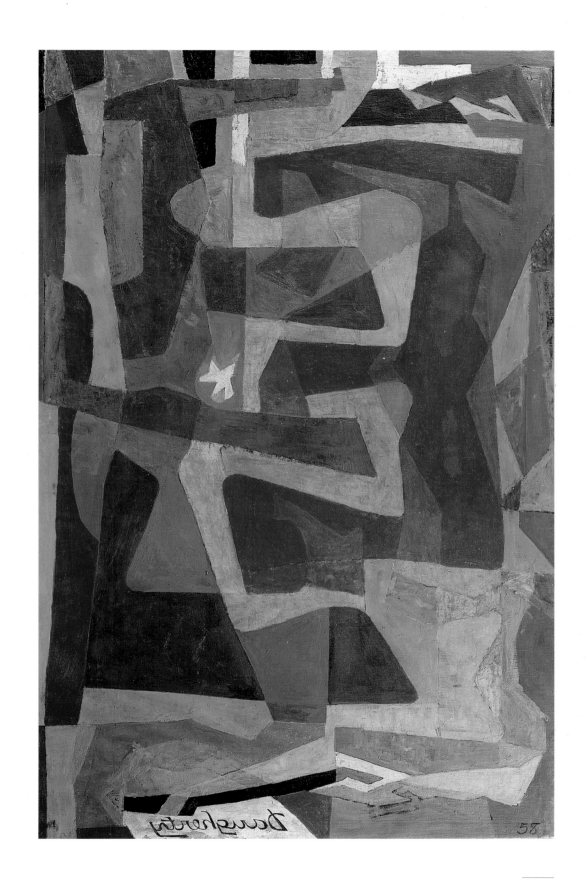

6. *ALDRIN*, 1958,
oil on canvas,
66¾ × 42 inches

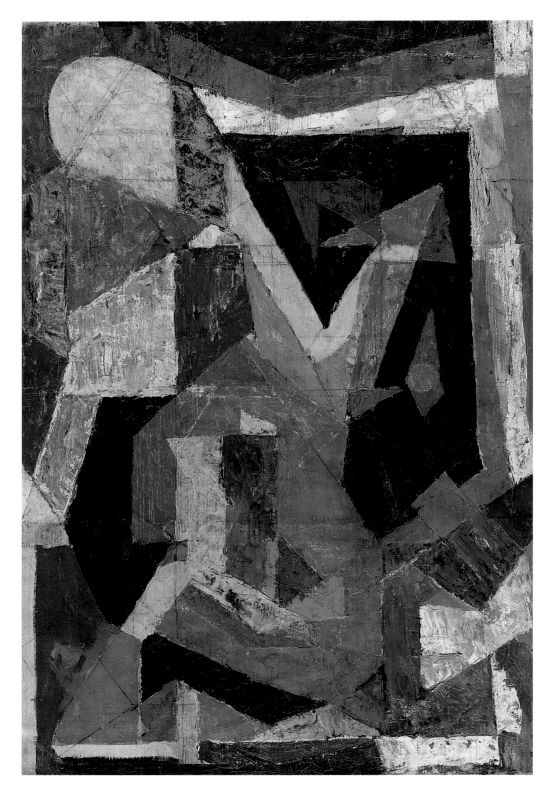

7. *ABSTRACT NUMBER 9*, ca. 1960, oil on canvas, 36 × 24 inches

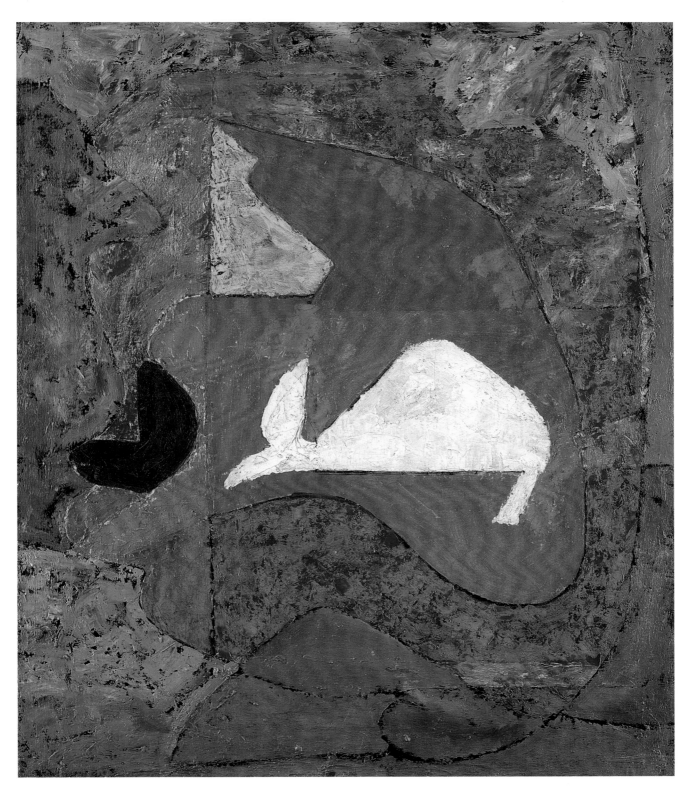

8. *ABSTRACTION*, ca. 1965, oil on canvas, 24 × 20 inches

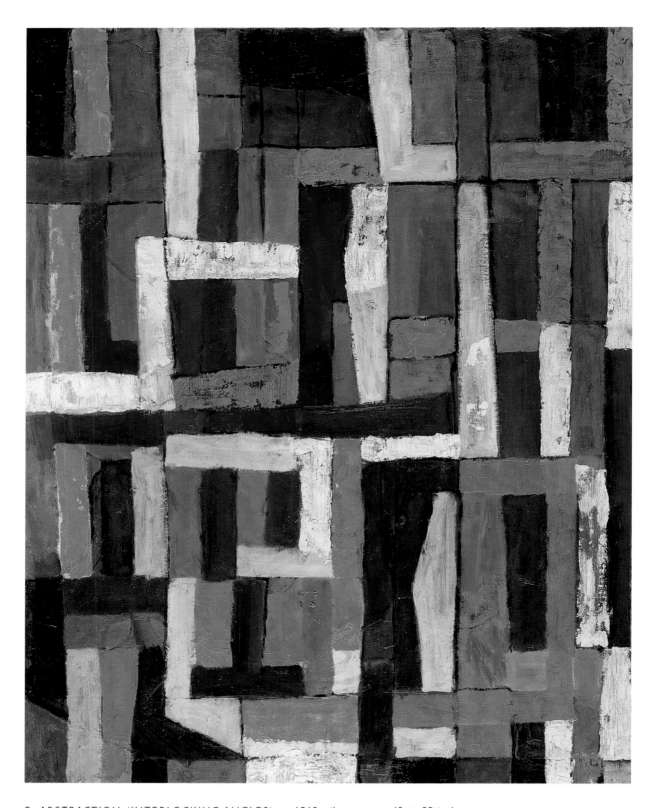

9. *ABSTRACTION (INTERLOCKING ANGLES)*, ca. 1960, oil on canvas, 40 × 32 inches

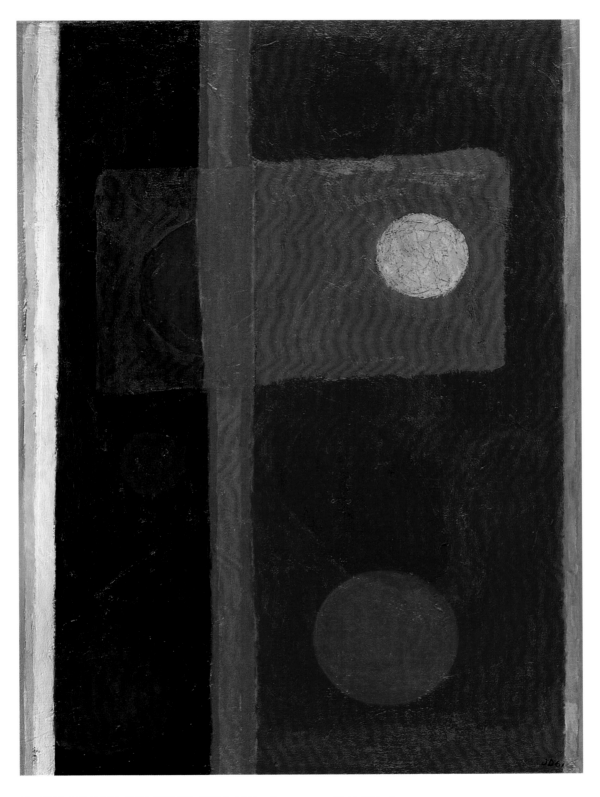

10. *THE DAY THE SUN STOOD STILL*, 1961, oil on canvas, 41 × 30 inches

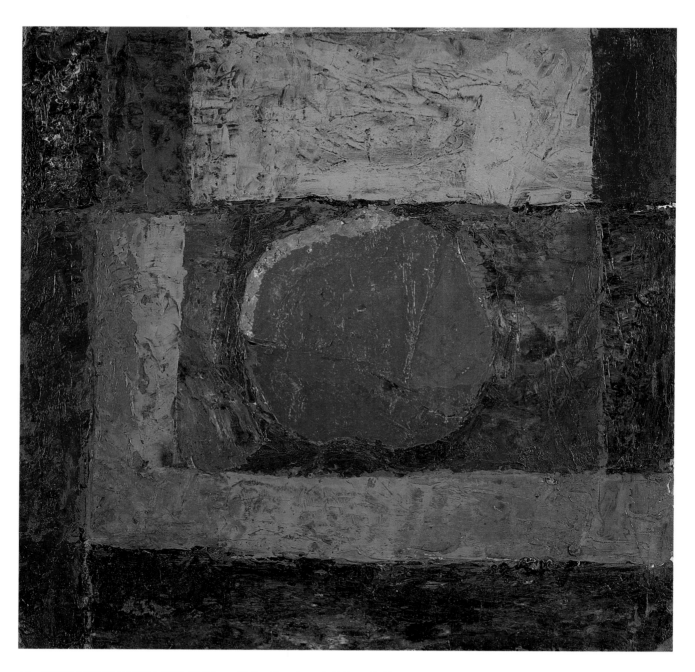

11. *ABSTRACTION WITH RED SUN*, ca. 1960, oil on board, 11½ × 11½ inches

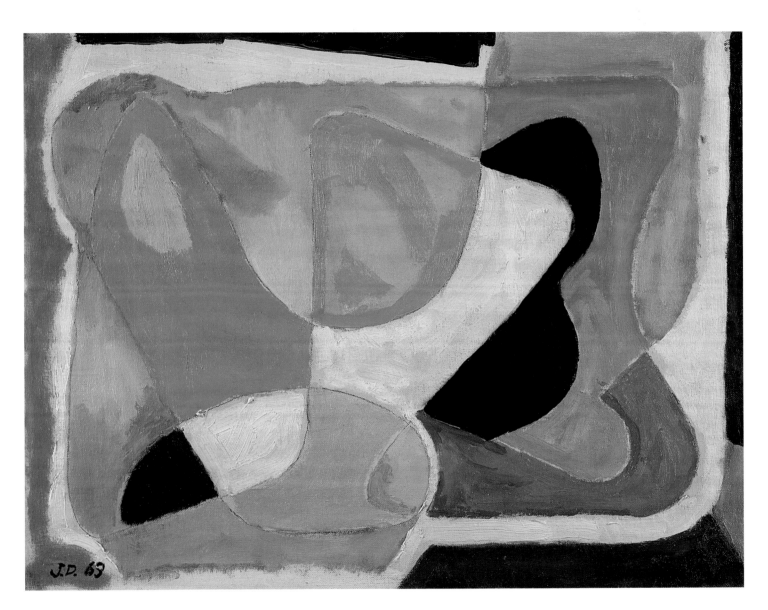

12. *THE ROAD TO DAMASCUS*, 1963, oil on canvasboard, 16 × 20 inches

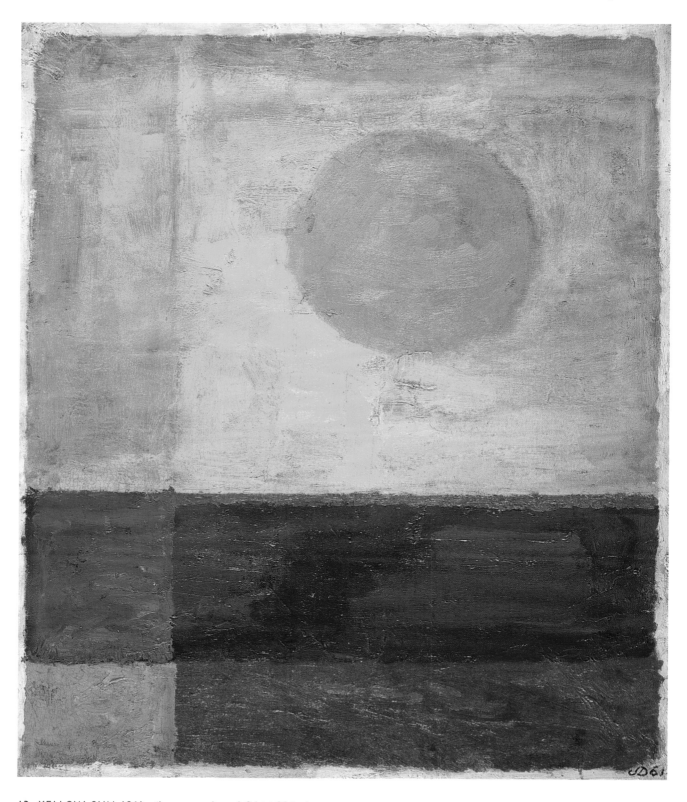

13. *YELLOW SUN*, 1961, oil on canvasboard, 24 × 20 inches

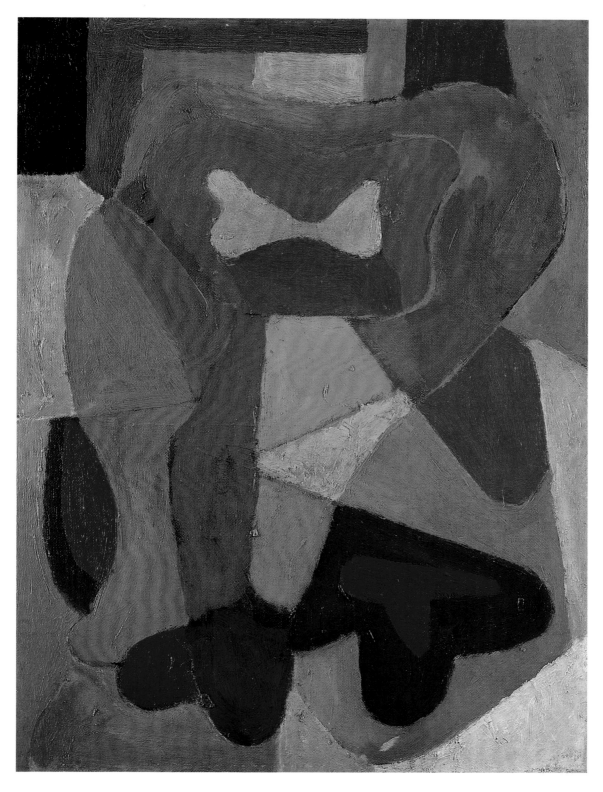

14. *ABSTRACTION*, ca. 1965, oil on canvasboard, 16 × 12 inches

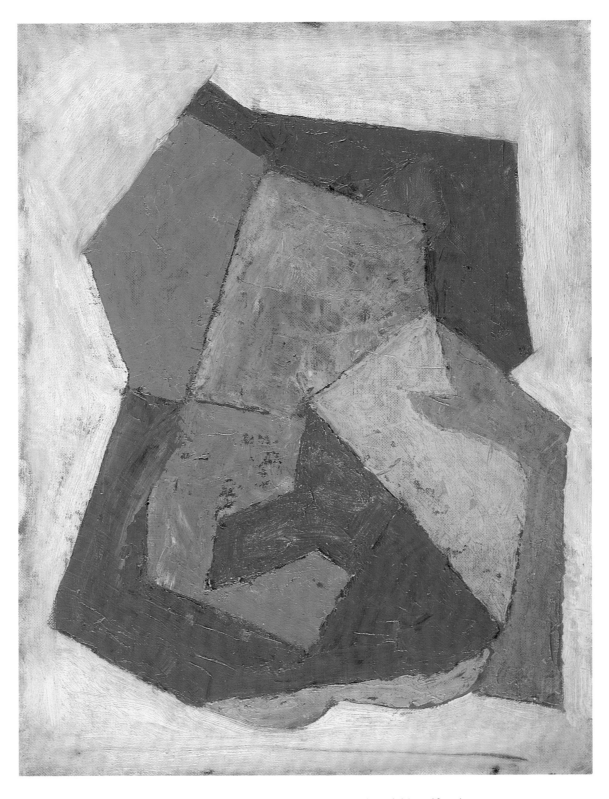

15. *ABSTRACTION WITH WHITE BORDER*, ca. 1965, oil on canvasboard, 16 × 12 inches

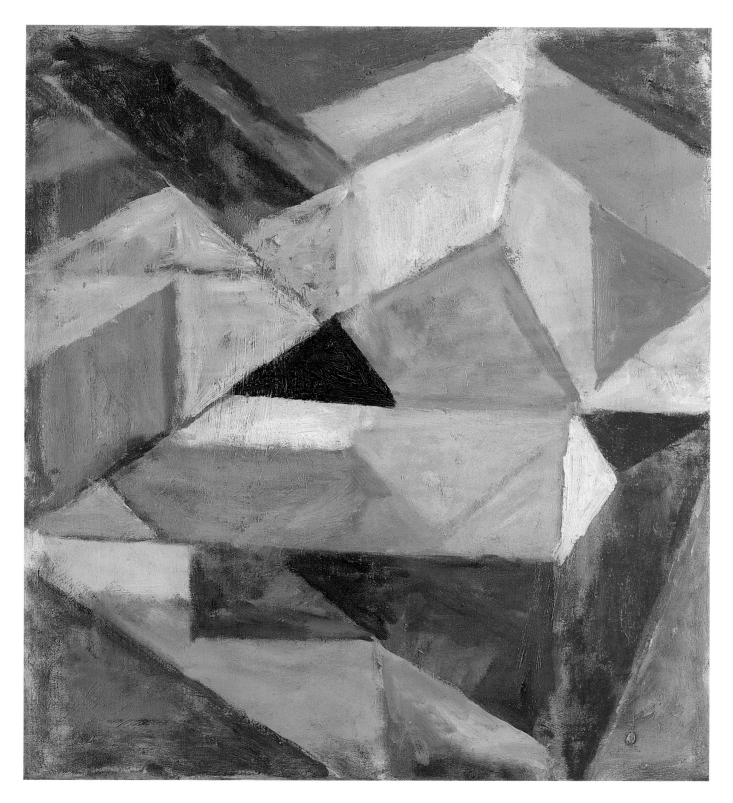

16. *ABSTRACTION*, ca. 1965, oil on canvas, 20 × 18 inches

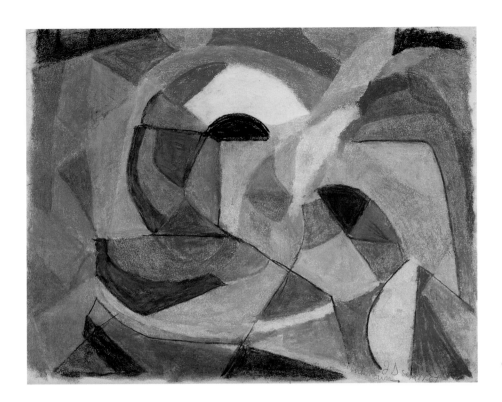

17. *DESTINATION UNKNOWN*, 1967,
oil pastel on paper,
13¾ × 16¾ inches

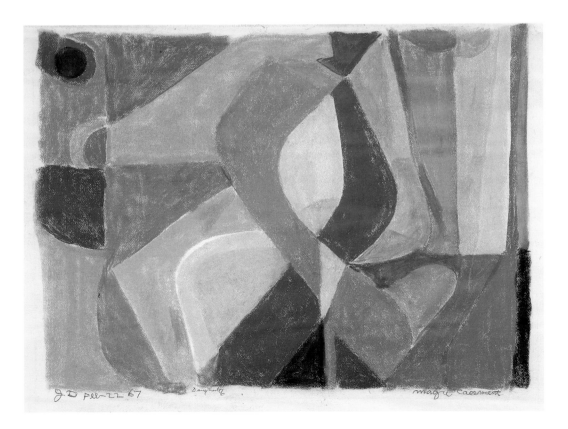

18. *MAGIC CASEMENT*, 1967,
oil pastel on paper,
17½ × 22½ inches

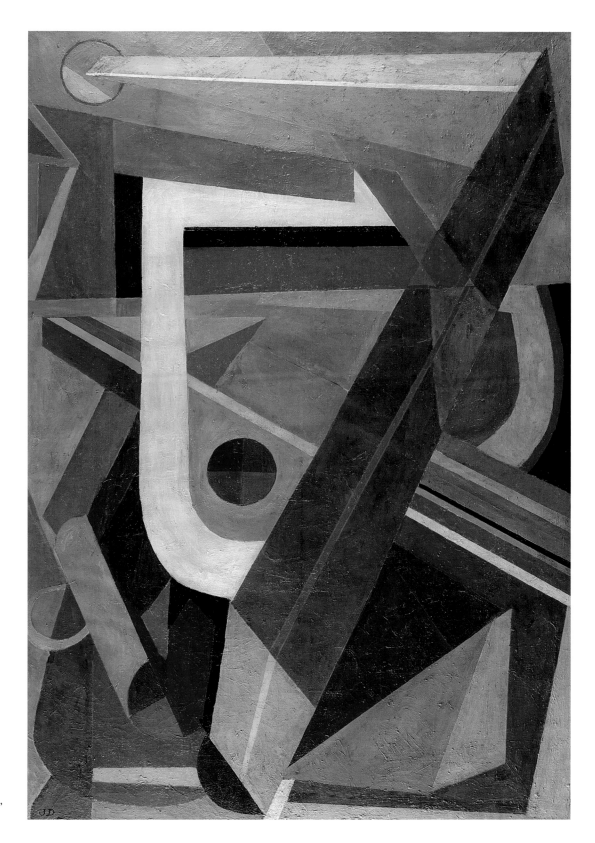

19. *CAPE CANAVERAL*, 1965,
oil on canvas, 72 × 48 inches

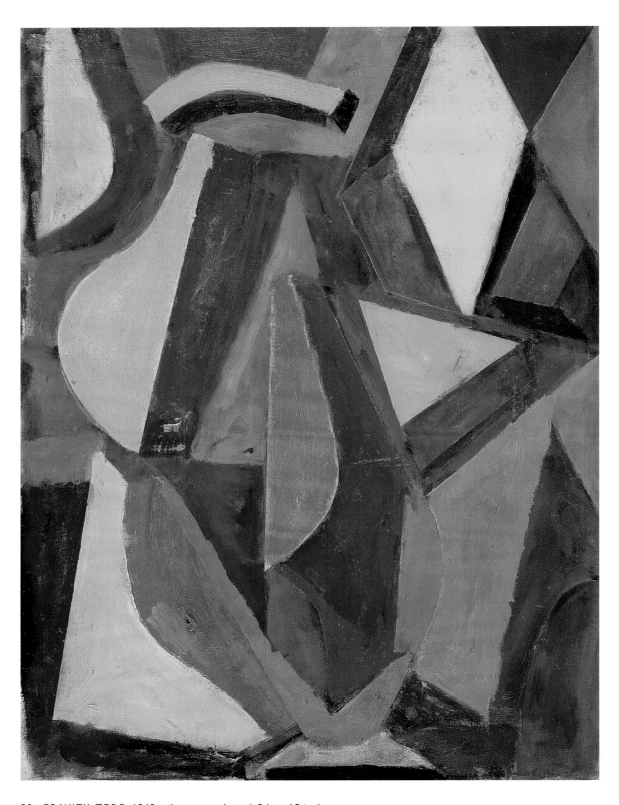

20. *GRAVITY ZERO*, 1969, oil on canvasboard, 24 × 18 inches

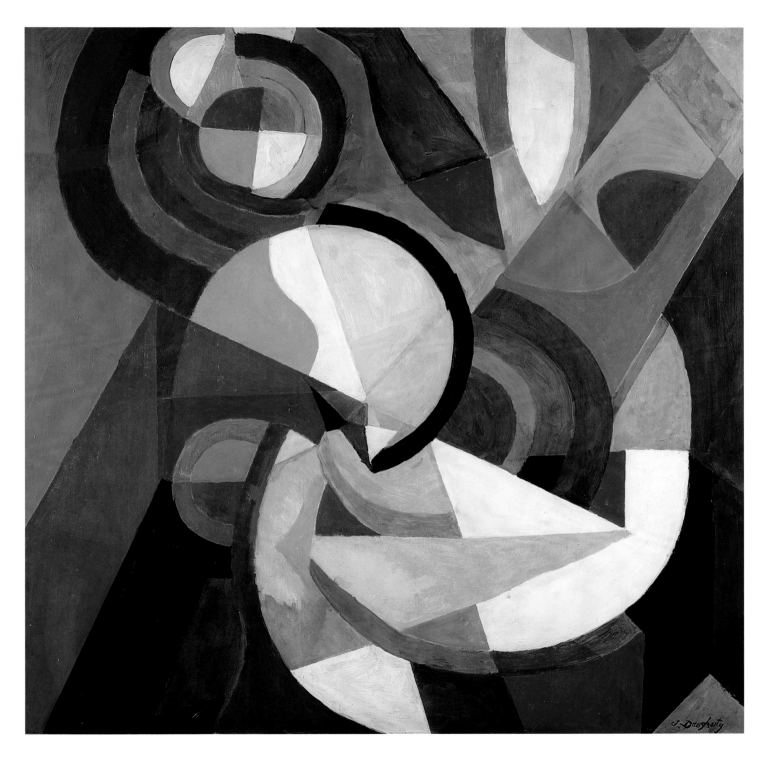

21. *SIMULTANEOUS*, ca. 1965, oil on canvas, 50 × 50 inches

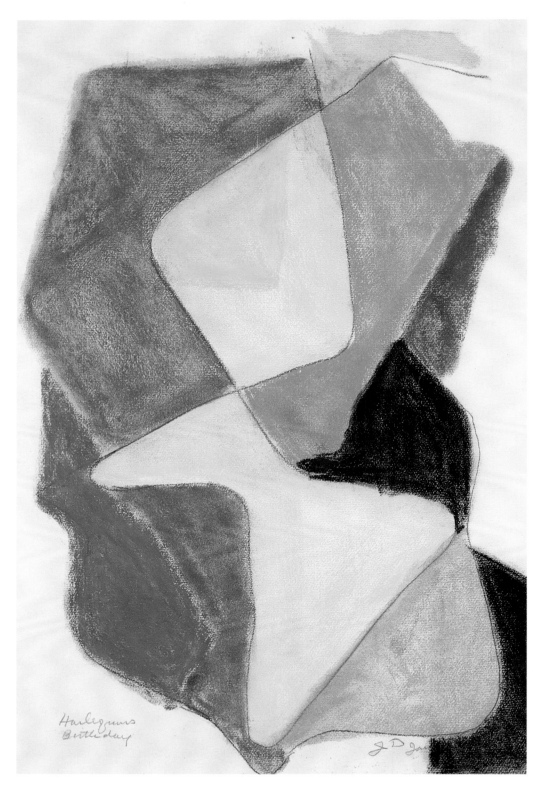

22. *HARLEQUIN'S BIRTHDAY*, ca. 1965, oil pastel on paper, 17¾ × 12 inches

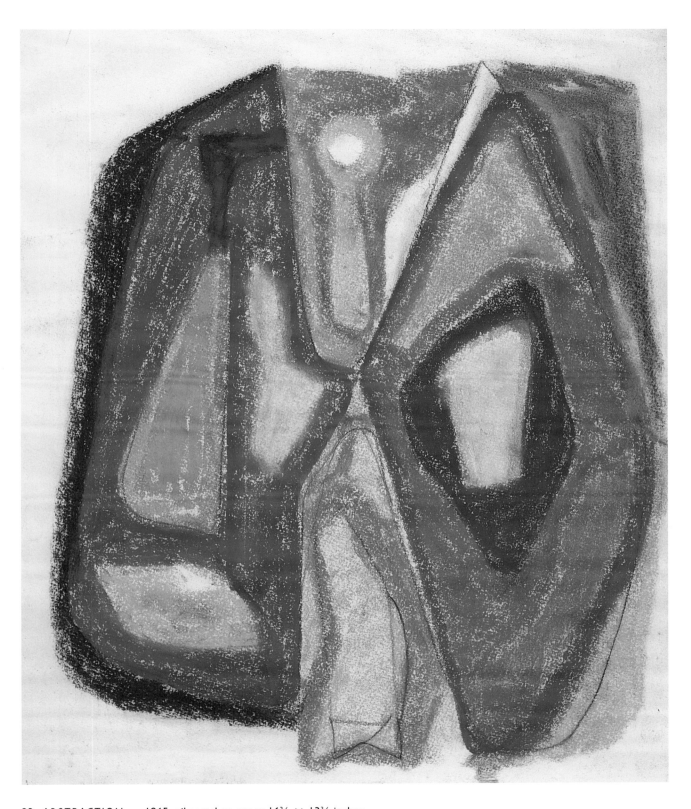

23. *ABSTRACTION*, ca. 1965, oil pastel on paper, 16¾ × 13¾ inches

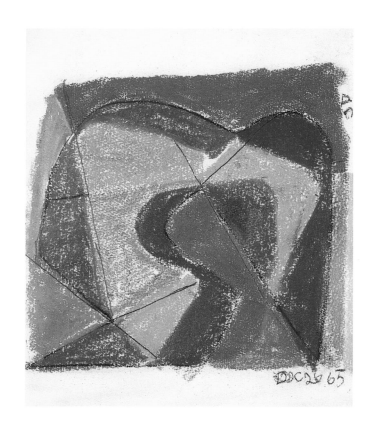

24. *DEC 26 65*, 1965,
oil pastel on paper, 10 × 8 inches

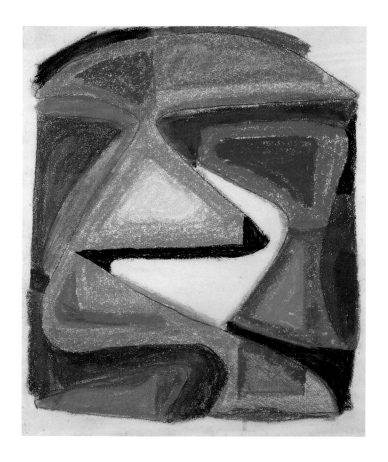

25. *ABSTRACTION IN BLUE*, ca. 1965,
oil pastel on paper, 16¾ × 13¾ inches

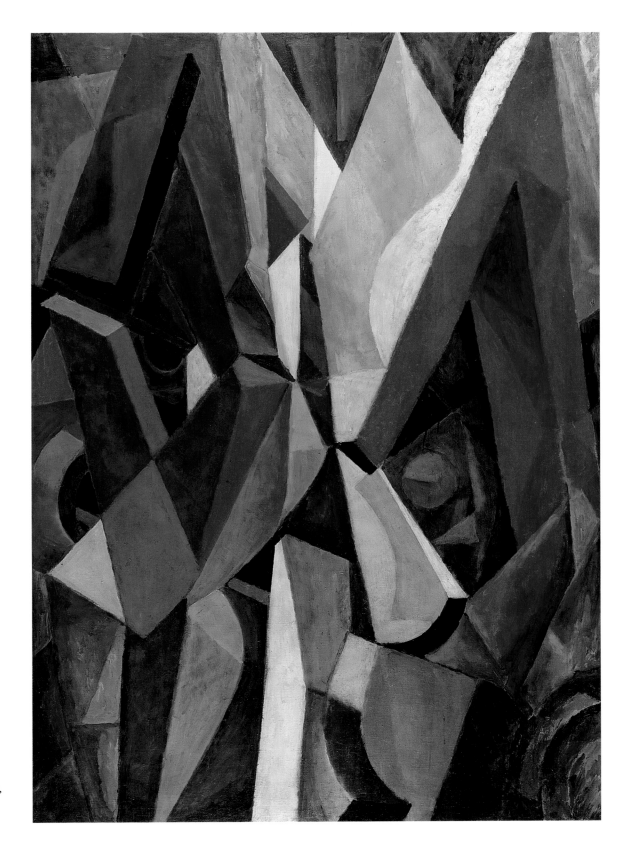

26. *SIMULTANEOUS COLOR PLANES*, 1969, oil on canvas, 68 × 48 inches

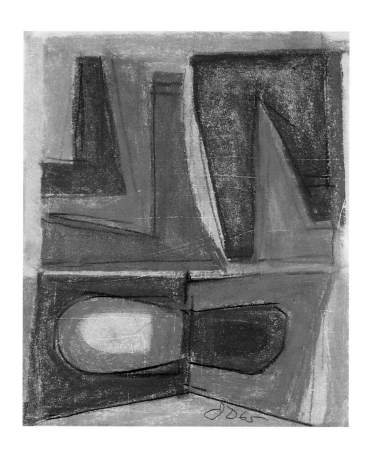

27. *65*, 1965,
oil pastel on paper,
12 × 9 inches

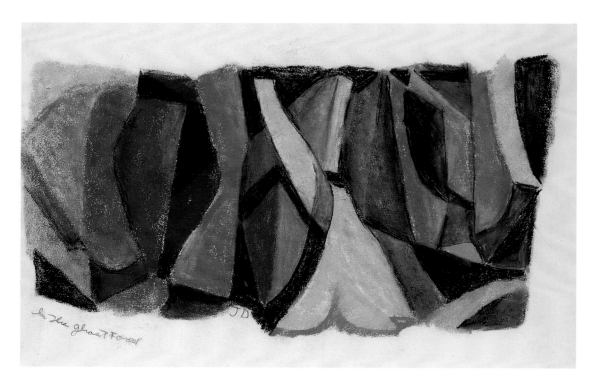

28. *IN THE GHOST
FOREST*, ca. 1965,
oil pastel on paper,
12 x 17¾ inches

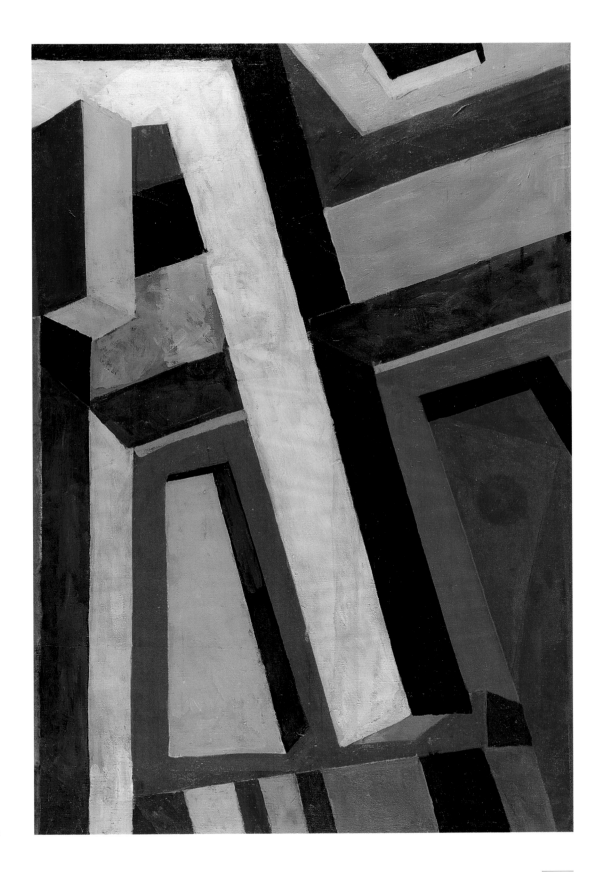

29. *ABSTRACTION*, 1965,
oil on canvas, 60 × 40 inches

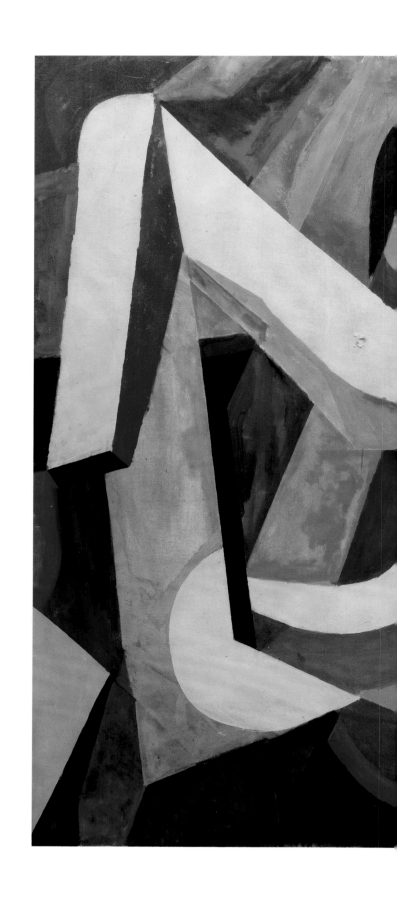

30. *ALTAR TO THE UNKNOWN GOD*,
ca. 1970–71, acrylic on canvas, 78 × 113 inches

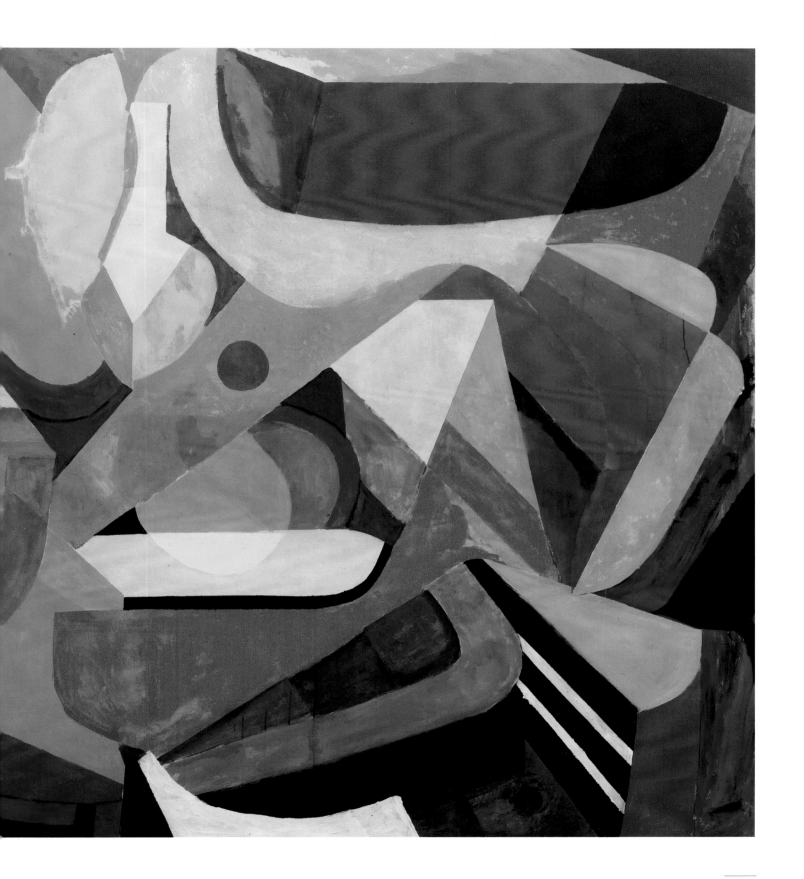

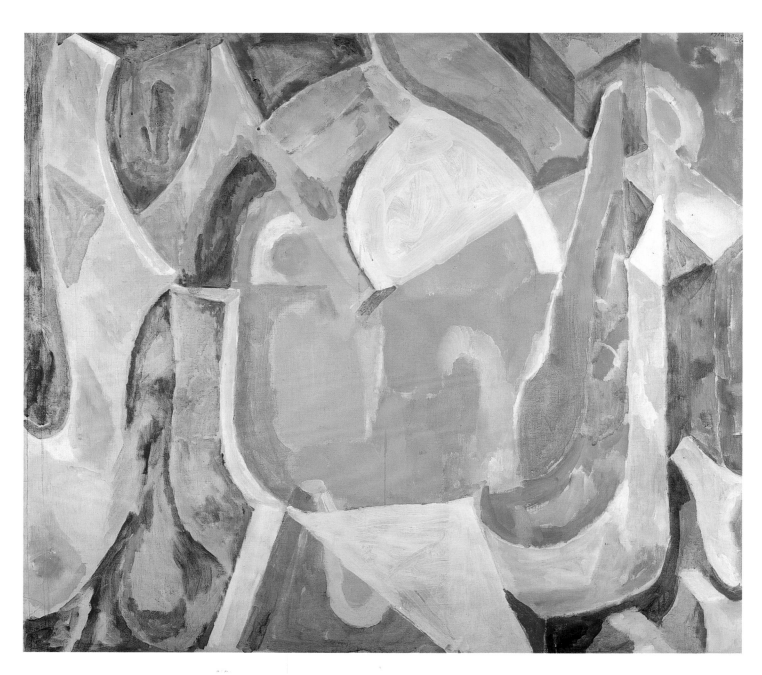

31. *AUGUST 1972*, 1972, acrylic on canvas, 48 × 54 inches

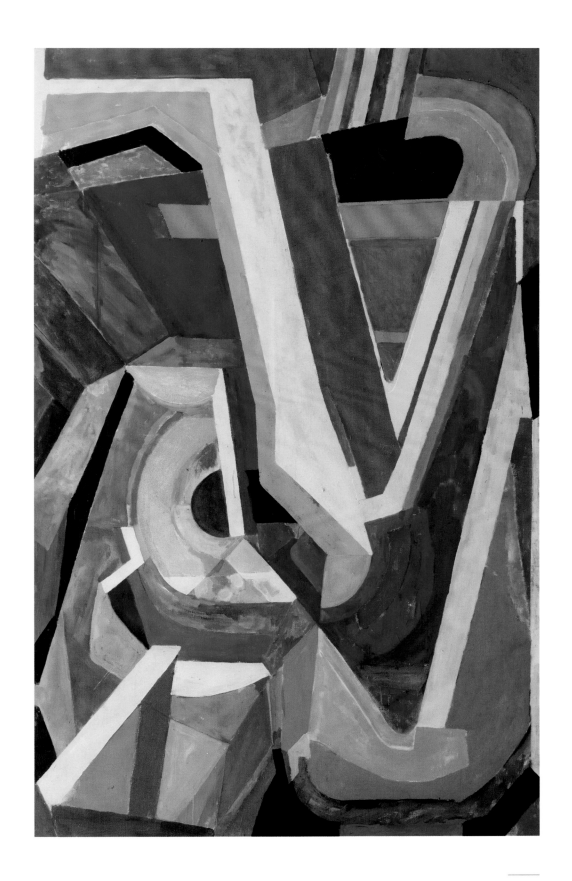

32. *ABSTRACTION*, ca. 1970,
oil on canvas, 96 × 60 inches

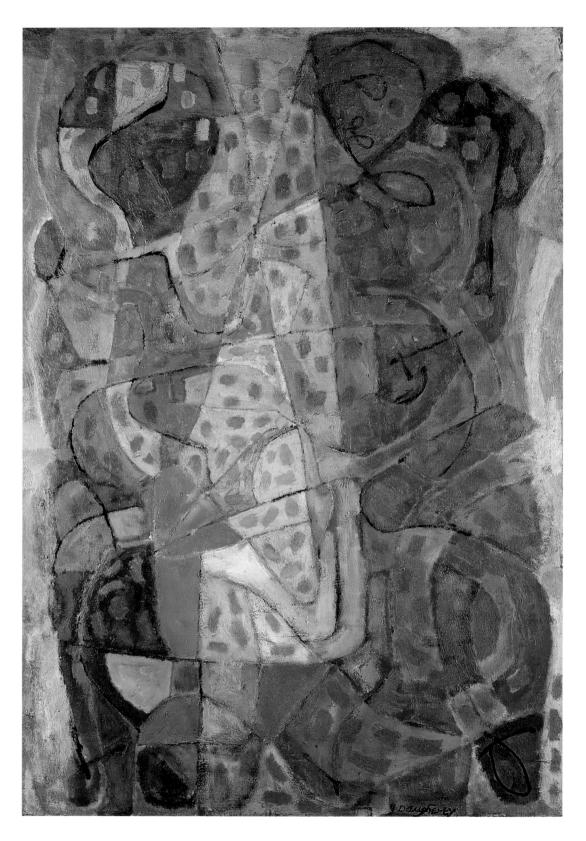

33. *SAGITTARIUS*, ca. 1970,
acrylic on canvas,
50¼ × 34 inches

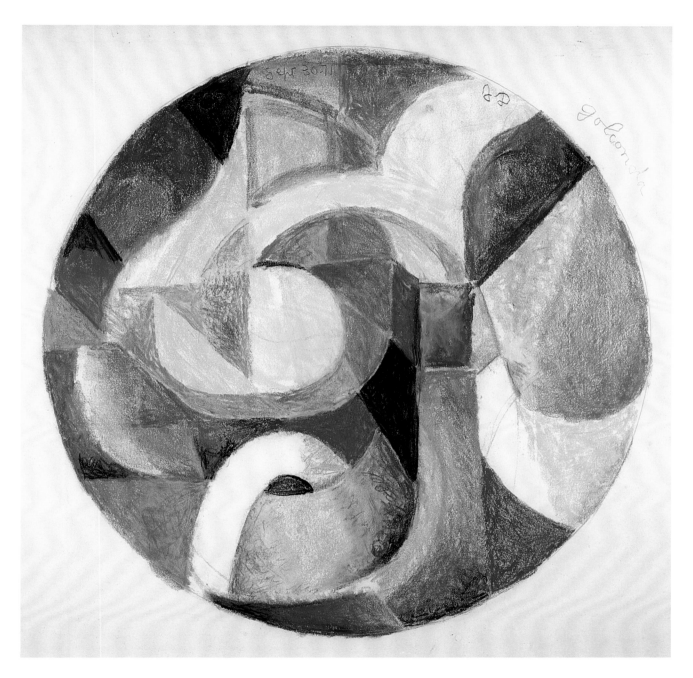

34. *GOLCONDA*, 1971, oil pastel on paper, 21½ × 21½ inches

JAMES DAUGHERTY: CHRONOLOGY

1887
Born, June 1 in Asheville, North Carolina, the first child of Susan Peyton Telfair Daugherty and Charles Michael Daugherty.

1887–ca. 1896–97
Spent childhood in southern Indiana and Wilmington, Ohio, where his father was a farmer.

ca. 1896–97
Moved with his parents to Washington, D.C., where father worked as a statistician in the U.S. Department of Agriculture.

1903
First art instruction in the evening classes at the Corcoran School of Art, Washington, D.C. May 28; received the school's honorable mention certificate. Studied with Hugh Breckenridge at the Darby Summer School of Painting, Fort Washington, Pennsylvania.

1904
March, illustration for *Treasure Island* published in *Sketch Book*.

1904–05
Studied for six months with William Merritt Chase and Henry McCarter at the Pennsylvania Academy of the Fine Arts in Philadelphia; his classmates included Morton Schamberg and Charles Sheeler.

1905
Traveled to Europe with sculptor Hunt Diederich. Lived with his parents in London, where his father represented the U.S. Department of Agriculture.

1905–07
Studied with Frank Brangwyn at the London School of Art. Traveled to Amsterdam, the Hague, Brussels, Paris, Venice, and Rome. In Paris, studied briefly at the Académie Colarossi.

ca. 1907
After return to the United States, moved to New York City.

ca. 1909–11
Resided in the New York suburb of Leonia, New Jersey, near his friend Arthur Covey, a muralist who had been associated with Brangwyn in London, 1903–08.

ca. 1908–12
Sold illustrations to *Harper's Weekly* and *Colliers* as well as to the Otis Book series of the American Book Company.

1911
Studied etching at National Academy of Design, New York. Moved to Brooklyn Heights. Made friends with artists Walt Kuhn, Walter Pach, and George Overbury "Pop" Hart. Met Katherine Dreier, patron and promoter of avant-garde art.

1912
Married Sonia Medvedeva (b. 1893, Moscow, Russia).

1913
Saw the Armory Show in New York. Read C. Lewis Hind's *The Post-Impressionists* (London, 1911). Birth of son, Charles on November 17. Exhibited for the first time at the Pennsylvania Academy of the Fine Arts.

1914
Participated in a group show at the MacDowell Club in New York. Created futurist-style illustrations for the *New York Herald* magazine section. Created cartoons and caricatures for the *New York Evening Sun*.

1915
Met Arthur B. Frost, Jr., who had taken the artist's studio adjacent to Daugherty's in New York. Began to make abstract drawings. Exhibited for the first time at the Whitney Studio Club, New York.

1915–22
Painted abstract and near-abstract paintings based on simultaneous color theories.

ca. 1916
Joined The Penguin, a private organization of New York artists including Jules Pascin, "Pop" Hart, and Walt Kuhn.

1917
Participated in the first exhibition of the Society of Independent Artists in New York.

1918
Living in Greenwich Village, New York. Met Joseph Stella and Marcel Duchamp. Painted camouflage on Navy warships at Newport News and Baltimore. Created posters for the war effort as a contributing artist of the Division of Pictorial Publicity of the Committee on Public Information.

1920
Participated in first two exhibitions of the Société Anonyme, founded by Katherine Dreier and Marcel Duchamp. Began painting set of four murals on aspects of the four continents for Loew's State Theater in Cleveland (now Playhouse Square); murals completed February 1921. Painted a mural for Loew's Theater, Newark.

1922
Became a charter member of Modern Artists of America, Inc.

1923
Moved to a pre-Revolutionary country farmhouse in Weston, Connecticut. Served on Board of Directors of the Society of Independent Artists. Met Jan Matulka.

1925 – ca. 1927
Created illustrations for *The New Yorker*, including front covers, using the pseudonym of Jimmie the Ink (or Jimmy the Ink).

1926
Illustrated Stewart Edward White's book, *Daniel Boone*. Painted at least four mural panels for the President Hotel in Atlantic City and as many as twenty for the Thomas Cook pavilion at the *Philadelphia Sesquicentennial Exposition*. John Steuart Curry worked as his assistant.

1926–27
Exhibited *Wall Decoration*, a large figurative painting, at the Brooklyn Museum's *International Exhibition of Modern Art*, assembled by Katherine Dreier and the Société Anonyme.

1929
Painted "mural map" for Geneva International Congress.

1932
Painted mural, *Overture to 1776*, for *George Washington Bicentennial Exhibition* at National Gallery, Washington, D.C.

1934
Painted a mural cycle of seven panels on American themes for the octagonally-shaped auditorium of Stamford High School, Connecticut. Painted mural, *Nursery Tales*, for Holmes Elementary School, Darien, Connecticut.

1935
Painted mural, *Life and Times of General Putnam*, for Greenwich, Connecticut, Town Hall. Painted four mural panels for Woodfield, a children's village settlement in Fairfield, Connecticut (now, Discovery Museum, Bridgeport). Exhibited in a show of mural designs submitted for federal building projects, Corcoran Gallery of Art, Washington, D.C.

1937
Painted eight mural panels on the idea of "The Democracy" for the social room of Fairfield Court, a public housing project in Stamford, Connecticut.

1938
Wrote and illustrated *Andy and the Lion*, which won a Caldecott Honor Medal. This was the first of many books for which Daugherty served as both the author and illustrator.

1939
Painted mural, *Illinois Pastoral*, for Virden, Illinois, post office. Painted two murals for the Thomas Cook & Son-Wagon Lits, Inc. exhibition at Golden Gate Exposition, San Francisco. Illustrated his own text of Daniel Boone, which won the John Newbery Medal in 1940 as the year's most distinguished contribution to American literature for children.

1940s–1970s
Wrote and illustrated many books. Painted figuratively, including a series of paintings on Biblical themes in the late 1940s and early 1950s.

1941
Yale University Art Gallery acquired Daugherty's masterwork *Mural Decoration* (ca. 1918) as part of the Société Anonyme/Katherine Dreier Bequest, probably Daugherty's first painting to enter a major museum collection.

1946–47
Spent winters in California with his family.

1947
Painted a series of fifteen oil paintings illustrating the text of Lincoln's "Gettysburg Address," published as a book by Albert Whitman & Co.

1953
Returned to abstract painting.

1954
One-man show at The Women's Club, Westport, Connecticut.

1956
Illustrated Benjamin Elkin's *Gillespie and the Guards*, which won a Caldecott Honor Medal in 1957. One-man show at Achenbach Foundation for Graphic Arts, San Francisco Public Library.

1959
Received Citation for Merit from the *Annual Society of Illustrators National Exhibition*.

1965
Exhibited in *Synchromism and Color Principles in American Painting 1910–1930* at M. Knoedler & Co. Galleries, New York, organized by William C. Agee.

1968
Presented his first gift of drawings and manuscripts relating to his illustrated books to the University of Oregon Library, Eugene.

1969
Daugherty's abstract painting *Simultaneous Contrasts* (1918) was given to the Museum of Modern Art, New York by Mr. and Mrs. Henry Reed.

1971
Wife Sonia passed away on May 4. One-man show, Robert Schoelkopf Gallery, New York.

1973
James H. Daugherty Retrospective Exhibition, held at Montclair Art Museum, New Jersey.

1974
Died February 21 in a Boston nursing home.

1975
Included in exhibition, *Avant-Garde Painting and Sculpture in America 1910–25*, at Delaware Art Museum, Wilmington. One-man retrospective show, Silvermine Guild of the Arts, New Canaan, Connecticut.

1977
Whitney Museum of American Art acquires *Picnic* (1916), bequest of Laurence H. Bloedel, and purchases *Three Base Hit (Opening Game)*, (1914).

1978–79
Daugherty's major works based on color principles are included in *Synchromism and American Color Abstraction* at Whitney Museum of American Art, New York.

PUBLIC COLLECTIONS

Achenbach Foundation for Graphic Arts, California Palace of the
 Legion of Honor, Fine Arts Museums of San Francisco
Ackland Art Museum, University of North Carolina, Chapel Hill
Allentown Art Museum, Pennsylvania
Amon Carter Museum, Fort Worth, Texas
Appalachian Cultural Museum, Appalachian State University, Boone,
 North Carolina
Asheville Art Museum, North Carolina
Atwater Kent Museum of Philadelphia History, Philadelphia
Bayly Art Museum, University of Virginia, Charlottesville
Bowdoin College Museum of Art, Brunswick, Maine
The Columbus Museum, Georgia
Darien Historical Society, Connecticut
The Detroit Institute of Arts, Michigan
The Discovery Museum, Bridgeport, Connecticut
Flint Institute of Arts, Michigan
The Frances Lehman Loeb Art Center, Vassar College,
 Poughkeepsie, New York
Greenwich Public Library, Connecticut
The Harry Ransom Humanities Research Center,
 University of Texas, Austin
Heckscher Museum, Huntington, New York
Hirshhorn Museum and Sculpture Garden,
 Smithsonian Institution, Washington, D.C.
Holmes Elementary School, Darien, Connecticut
Honolulu Academy of Arts, Hawaii
Hood Museum of Art, Dartmouth College, Hanover, New Hampshire
Hoover Institution, Stanford University, California
Housatonic Museum of Art, Housatonic Community College,
 Bridgeport, Connecticut
Kerlan Collection, Elmer L. Andersen Library, University of Minnesota
Lyman Allyn Art Museum, Connecticut College, New London
The Marion Koogler McNay Art Museum, San Antonio, Texas
The Montclair Art Museum, New Jersey
The Museum of Modern Art, New York
New Britain Museum of American Art, Connecticut

Portland Museum of Art, Maine
Playhouse Square Center, Cleveland, Ohio
Sheldon Swope Art Museum, Terre Haute, Indiana
Smithsonian American Art Museum, Washington, D.C.
The Snite Museum of Art, University of Notre Dame, Indiana
Société Anonyme Collection, Yale University Art Museum,
 New Haven, Connecticut
The Spencer Collection, The New York Public Library, New York
Telfair Academy of Arts and Sciences, Savannah, Georgia
United States Post Office, Virden, Illinois
University Art Museum of the University of New Mexico, Albuquerque
University of Oregon Library, Eugene
The Watkins Collection, American University Art Gallery,
 Washington, D.C.
Weatherspoon Art Gallery, University of North Carolina, Greensboro
Westport Public School Collection, Connecticut
Whitney Museum of American Art, New York
William Allen White Library, Emporia State University, Kansas
Wilmington Public Library, Ohio
YMCA, Westport, Connecticut